Draw 50

BUILDINGS AND OTHER STRUCTURES

BOOKS IN THIS SERIES

Draw 50 Airplanes, Aircraft, and Spacecraft
Draw 50 Animals
Draw 50 Athletes
Draw 50 Beasties and Yugglies and Turnover Uglies and Things That Go
Bump in the Night
Draw 50 Boats, Ships, Trucks, and Trains
Draw 50 Buildings and Other Structures
Draw 50 Cars, Trucks, and Motorcycles
Draw 50 Cats
Draw 50 Creepy Crawlies
Draw 50 Dinosaurs and Other Prehistoric Animals
Draw 50 Dogs
Draw 50 Endangered Animals
Draw 50 Famous Caricatures
Draw 50 Famous Cartoons
Draw 50 Famous Faces
Draw 50 Flowers, Trees, and Other Plants
Draw 50 Holiday Decorations
Draw 50 Horses
Draw 50 Monsters, Creeps, Superheroes, Demons, Dragons, Nerds, Dirts,
Ghouls, Giants, Vampires, Zombies, and Other Curiosa . . .
Draw 50 People
Draw 50 People of the Bible
Draw 50 Sharks, Whales, and Other Sea Creatures
Draw 50 Vehicles

Draw **50**
BUILDINGS AND
OTHER STRUCTURES

Lee J. Ames

MAIN STREET BOOKS

Doubleday

New York London Toronto Sydney Auckland

A MAIN STREET BOOK
PUBLISHED BY DOUBLEDAY
a division of Bantam Doubleday Dell Publishing Group, Inc.
1540 Broadway, New York, New York 10036

MAIN STREET BOOKS, DOUBLEDAY and the portrayal of a
building with a tree are trademarks of Doubleday, a
division of Bantam Doubleday Dell Publishing Group, Inc.

Library of Congress Cataloging-in-Publication Data
Ames, Lee J.
 Draw 50 buildings and other structures.

 1. Buildings in art. 2. Drawing—Technique.
I. Title.
NC825.B8A44 743'.8'4
ISBN: 0-385-14400-8
 0-385-14401-6 (lib. bdg.)
 0-385-41777-2 (pbk.)
Library of Congress Catalog Card Number 79-7483

To Alfie

Many thanks to Holly Moylan for all her help.

To the Reader

This book will show you a way to draw buildings, bridges and other structures. You need not start with the first illustration. Choose whichever you wish. When you have decided, follow the step-by-step method shown. ***Very lightly*** and ***carefully*** sketch out the step number one. However, this step, which seems the easiest, should be done ***most carefully.*** Step number two is added right to step number one, also lightly and also very carefully. Step number three is sketched right on top of numbers one and two. Continue this way to the last step.

It may seem strange to ask you to be extra careful when you are drawing what seem to be the easiest first steps, but this is most important, for a careless mistake at the beginning may spoil the whole picture at the end. As you sketch out each step, watch the spaces between the lines, as well as the lines, and see that they are the same. After each step, you may want to lighten your work by pressing it with a kneaded eraser (available at art supply stores).

When you have finished, you may want to reinforce the final step in India ink with a fine brush or pen. When the ink is dry, use the kneaded eraser to clean off the pencil lines. The eraser will not affect the India ink.

Here are some suggestions: In the first few steps, even when all seems quite correct, you might do well to hold your work up to a mirror. Sometimes the mirror shows that you've twisted the drawing off to

one side without being aware of it. At first you may find it difficult to draw the egg shapes, or ball shapes, or sausage shapes, or just to make the pencil go where you wish. Don't be discouraged. The more you practice, the more you will develop control.

In drawing these buildings I used much reference material to insure reasonable accuracy. I've also tried, in some of the drawings, to convey a *sense* of perspective, rather than full constructions with vanishing points and projections. These can come later.

The only equipment you'll need will be a medium or soft pencil, paper, the kneaded eraser and, if you wish, a ruler, a pen or brush and India ink—or a felt-tipped pen—for the final step. The first steps in this book are shown darker than necessary so that they can be clearly seen. (Keep your work very light.)

Remember there are many other ways and methods to make drawings. This book shows just one method. Why don't you seek out other ways from teachers, from libraries and, most important...from inside yourself?

LEE J. AMES

To the Parent or Teacher

"David can draw a building better than anybody else!" Such peer acclaim and encouragement generate incentive. Contemporary methods of art instruction (freedom of expression, experimentation, self-evaluation of competence and growth) provide a vigorous, fresh-air approach for which we must all be grateful.

New ideas need not, however, totally exclude the old. One such is the "follow me, step-by-step" approach. In my young learning days this method was so common, and frequently so exclusive, that the student became nothing more than a pantographic extension of the teacher. In those days it was excessively overworked.

This does not mean, however, that the young hand is never to be guided. Rather, specific guiding is fundamental. Step-by-step guiding that produces satisfactory results is valuable even when the means of accomplishment are not fully understood by the student.

The novice with a musical instrument is frequently taught to play simple melodies as quickly as possible, well before he learns the most elemental scratchings at the surface of music theory. The resultant self-satisfaction, pride in accomplishment, can be a significant means of providing motivation. And all from mimicking an instructor's "Do as I do."

Mimicry is prerequisite for developing creativity. We learn the use of our tools by mimicry. Then we can use those tools for creativity. To this end I would offer the budding artist the opportunity to memorize or mimic (rote-like, if you wish) the making of "pictures." "Pictures" he has been anxious to be able to draw.

The use of this book should be available to anyone who *wants* to try another way of flapping his wings. Perhaps he will then get off the ground when his friend says, "David can draw a building better than anybody else!"

LEE J. AMES

Draw 50

BUILDINGS AND OTHER STRUCTURES

Empire State Building (New York, U.S.A.)

Big Ben (London, England)

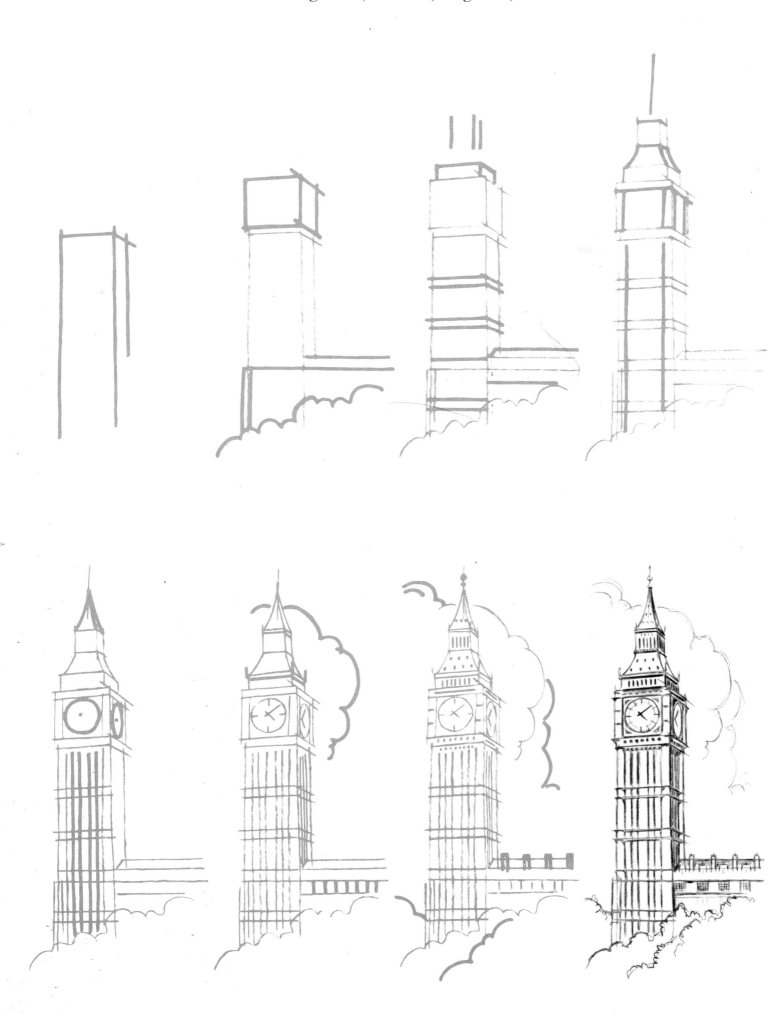

Transamerica Building (San Francisco, U.S.A.)

Taj Mahal (Agra, India)

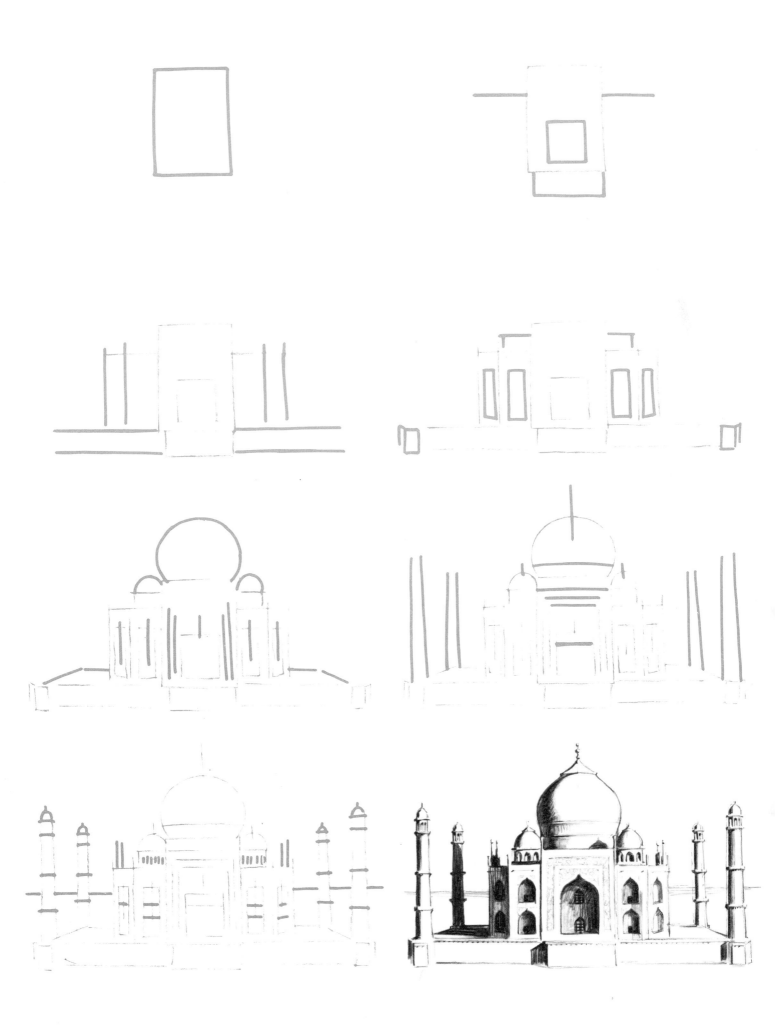

The Alamo (San Antonio, U.S.A.)

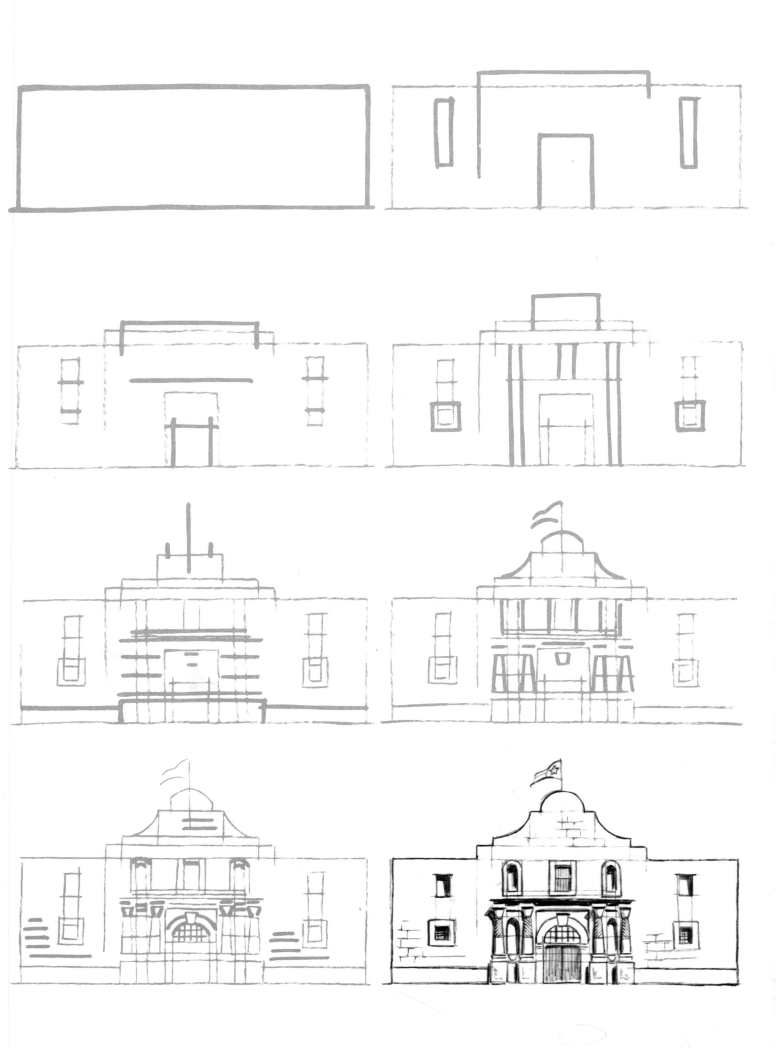

Alcazar (Segovia, Spain)

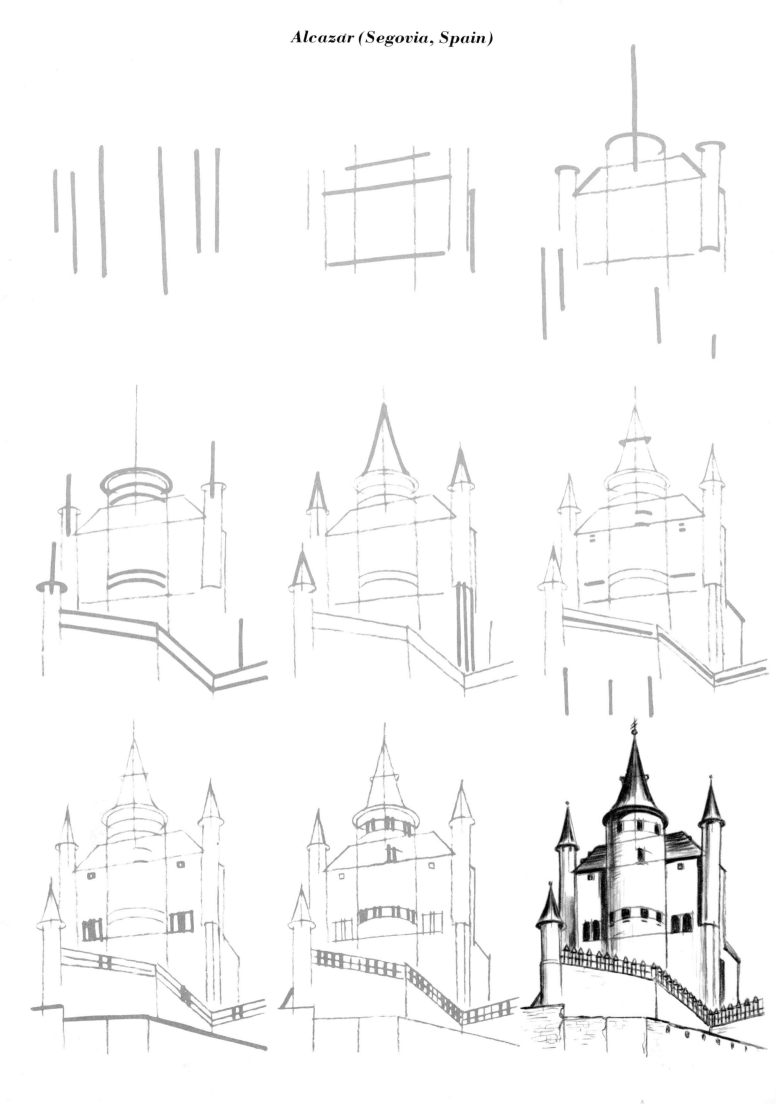

National Congress Buildings (Brasilia, Brazil)

The Parthenon (Greece)

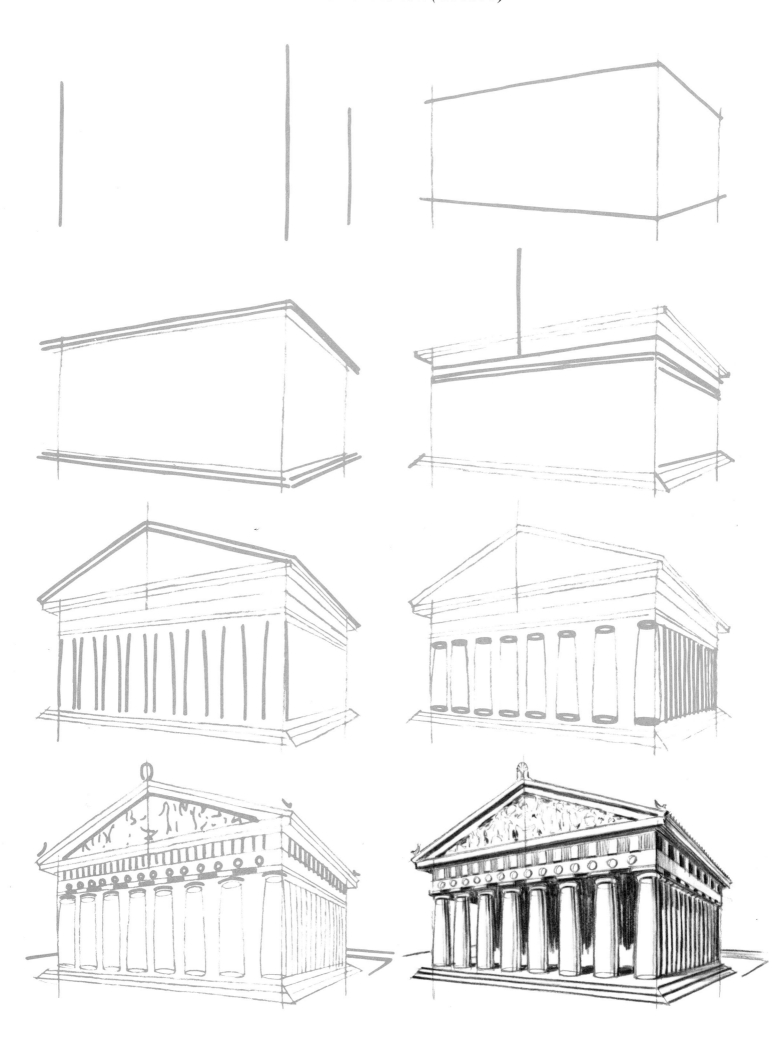

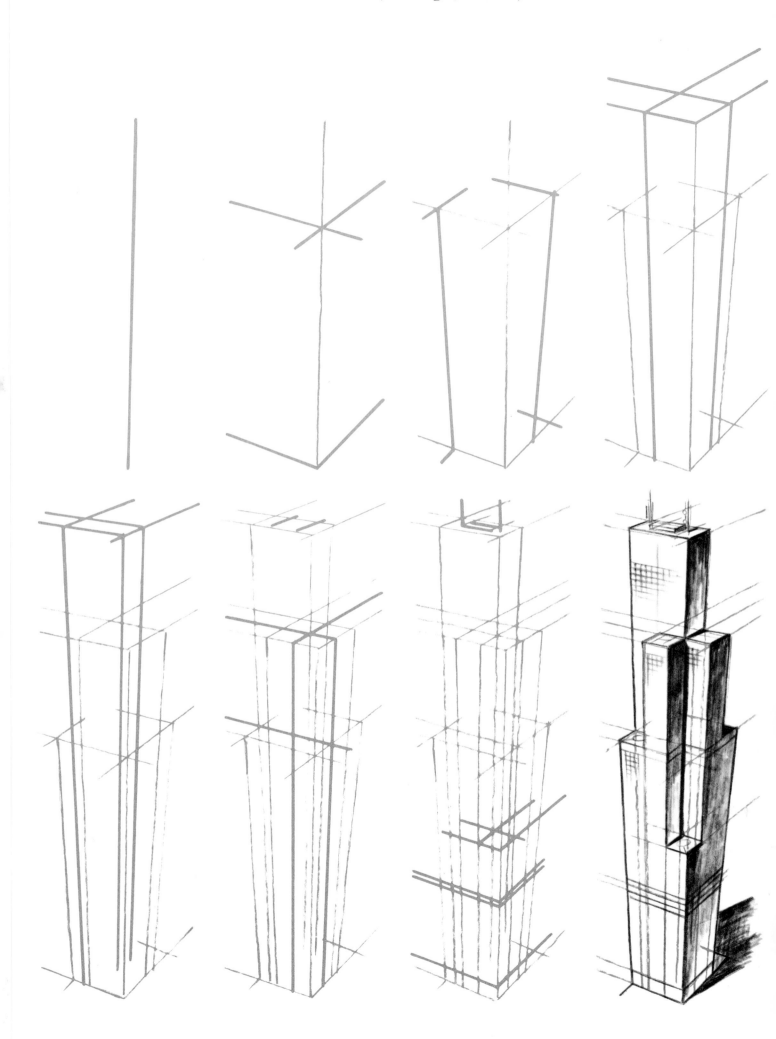

Dome of the Rock (Jerusalem, Israel)

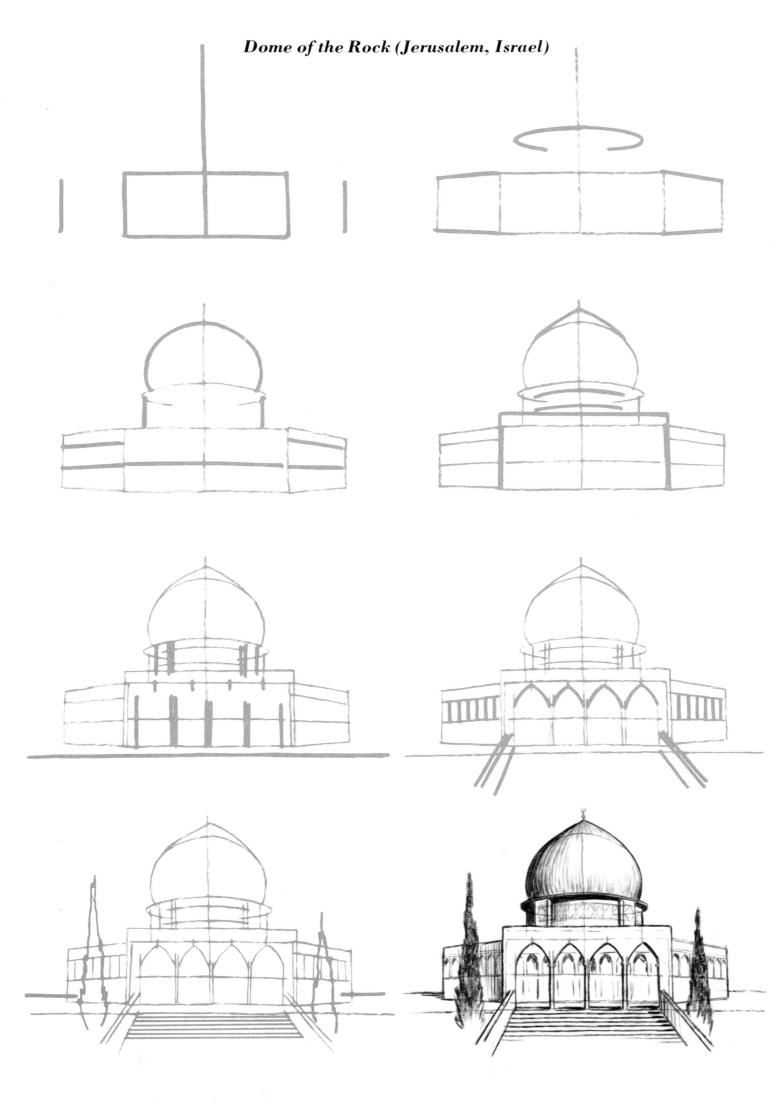

Rheims Cathedral (Rheims, France)

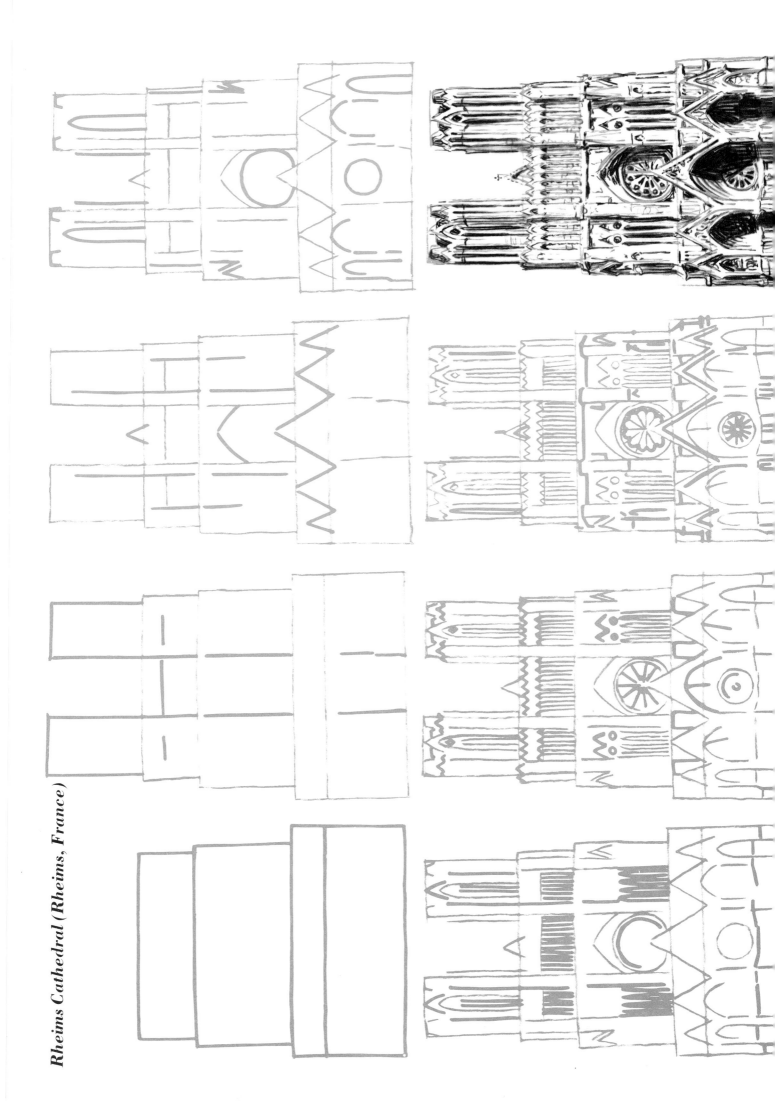

The Church of St. Basil (Moscow, U.S.S.R.)

Castle

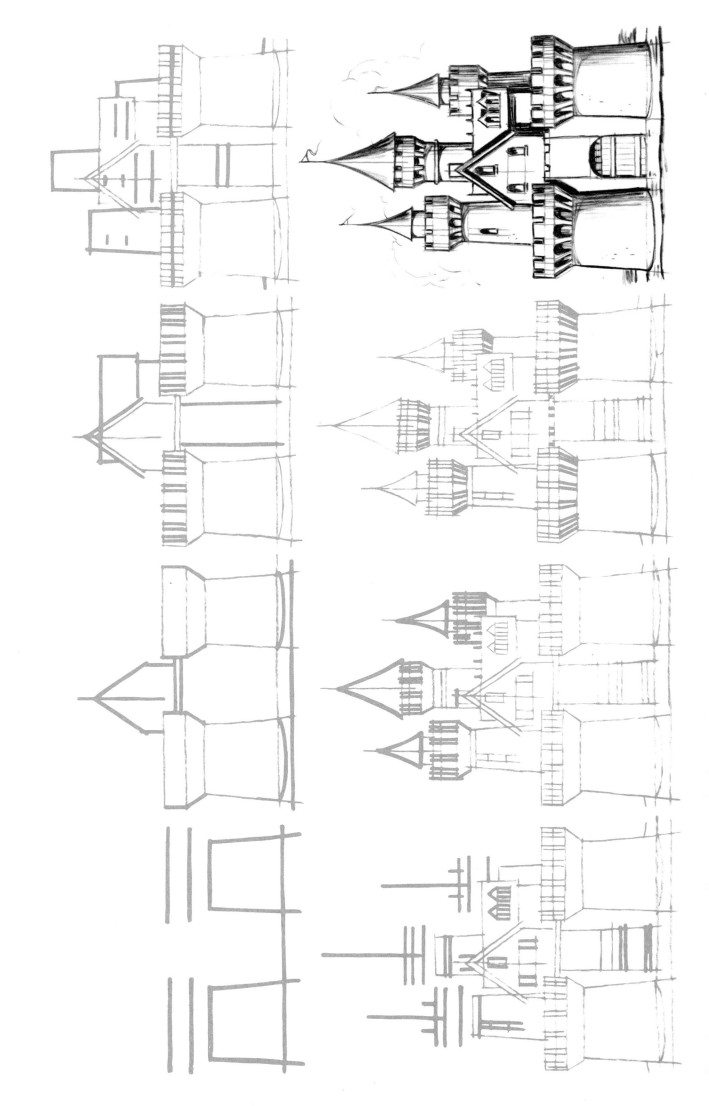

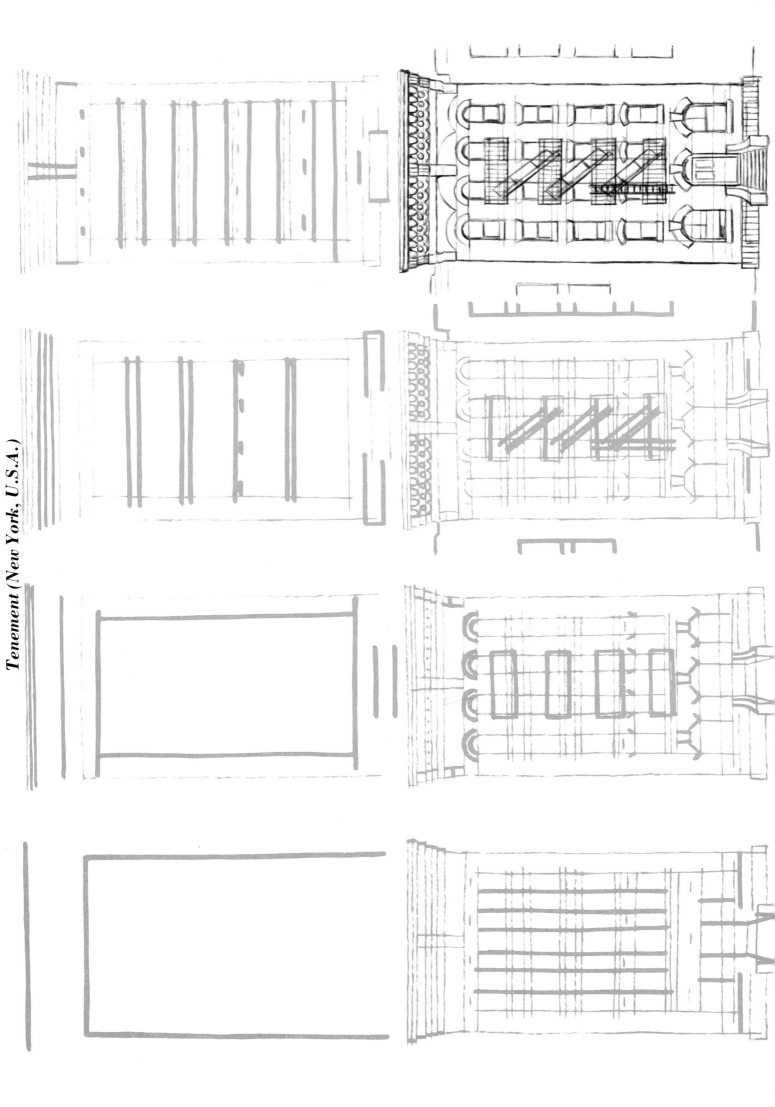

Tenement (New York, U.S.A.)

Chalet (Switzerland)

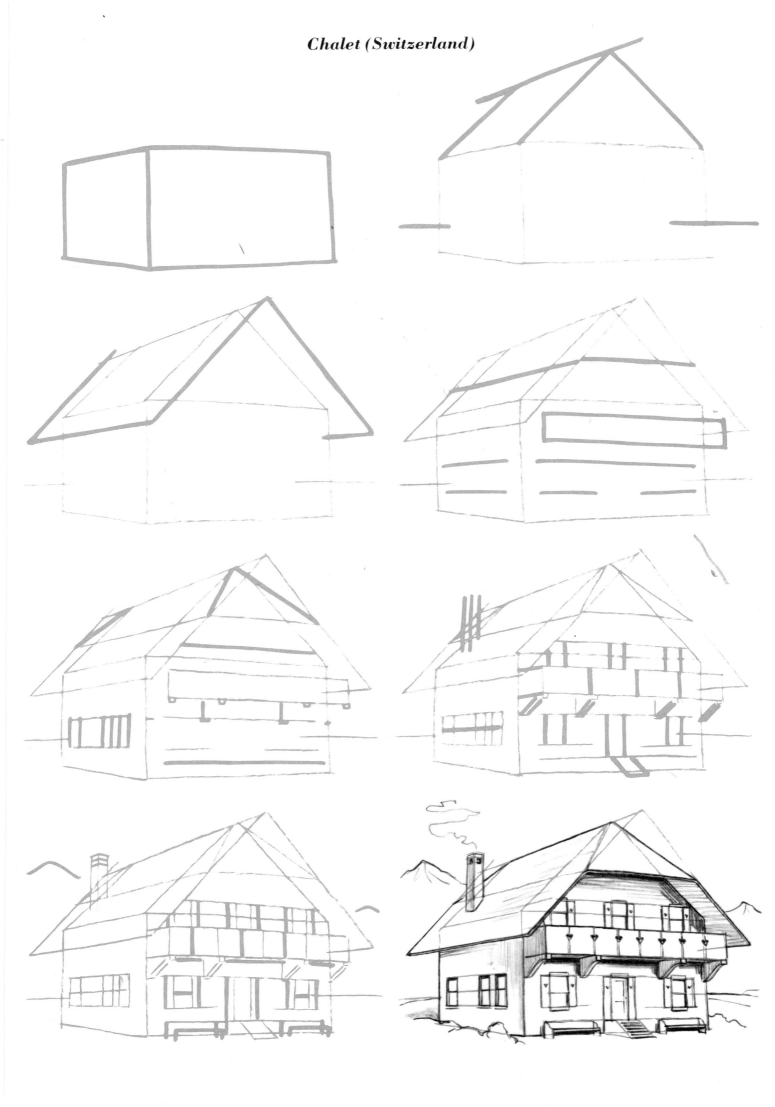

Pagoda (China)

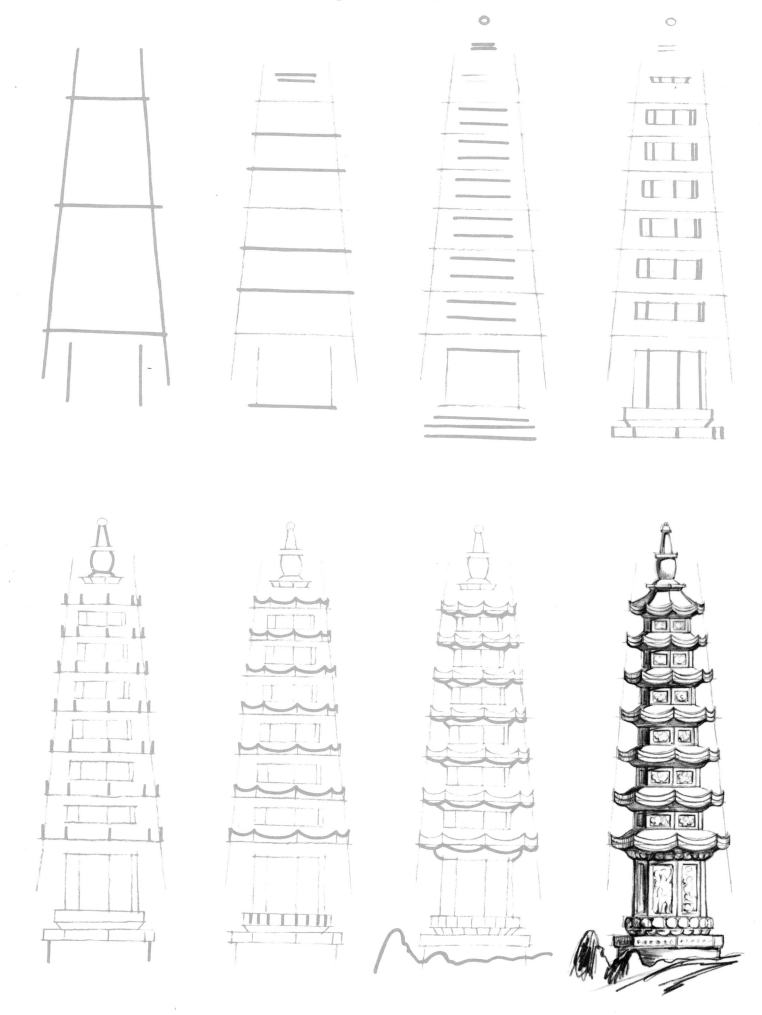

Georgian House (New Hampshire, U.S.A.)

Native House (Sumatra)

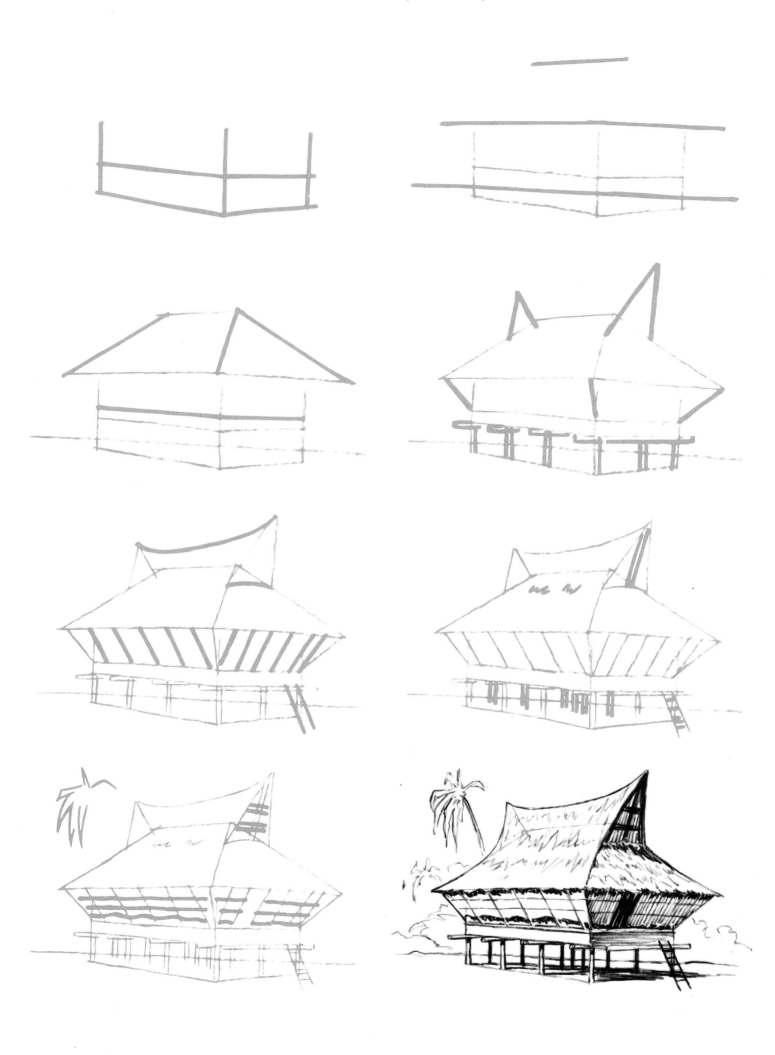

Pueblo Adobe Home (Southwest U.S.A.)

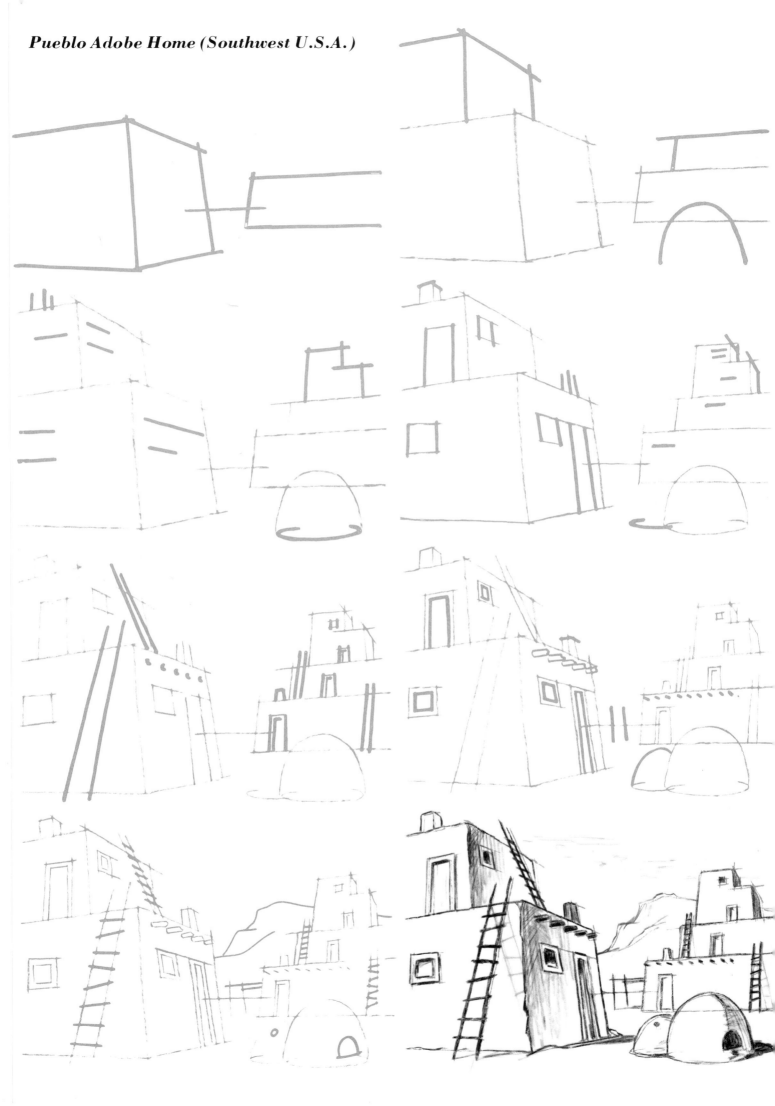

House, 1621 (Kent, England)

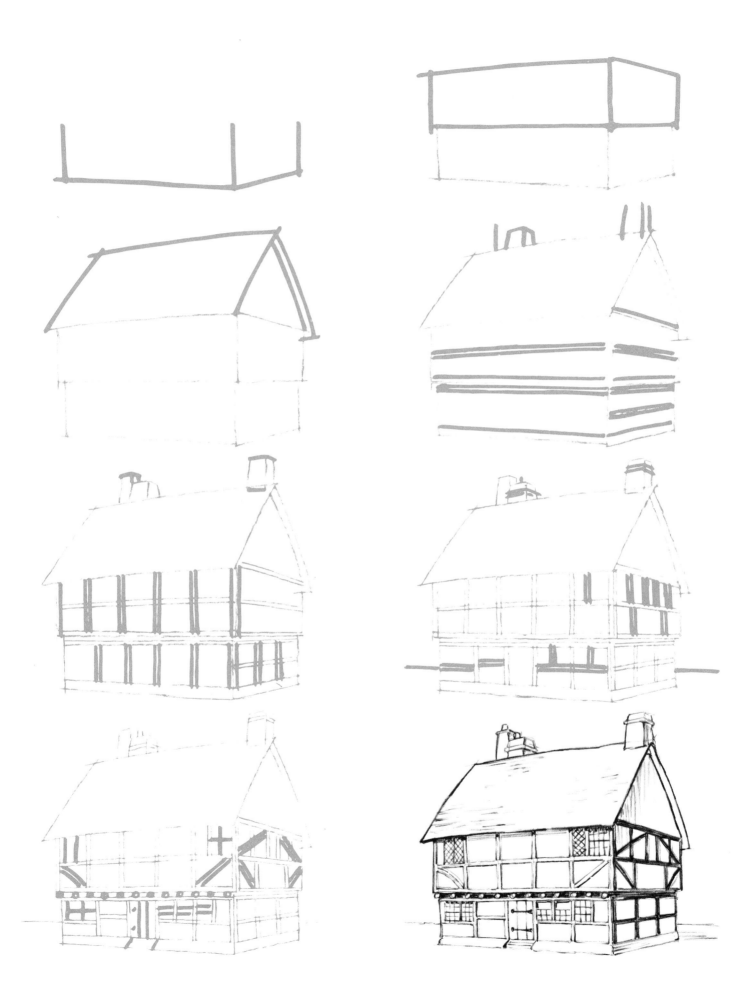

Salt Box House (Massachusetts, U.S.A.)

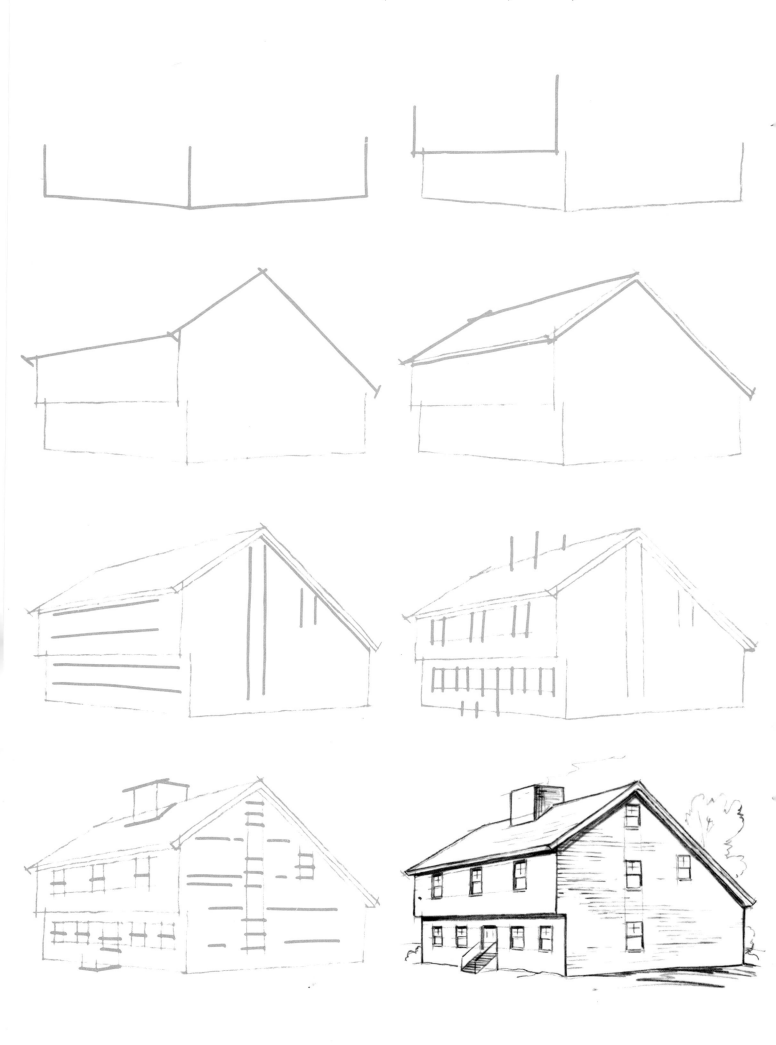

Modified Cape Cod House (U.S.A.)

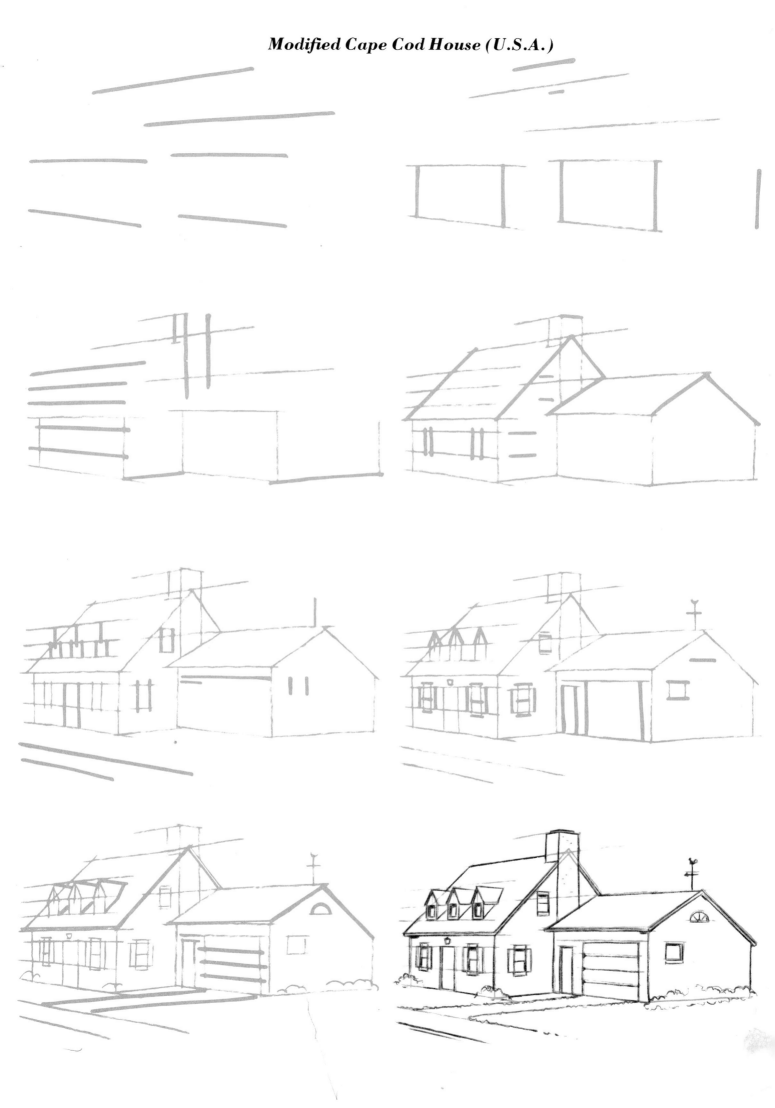

Thatched Cottage (Ireland)

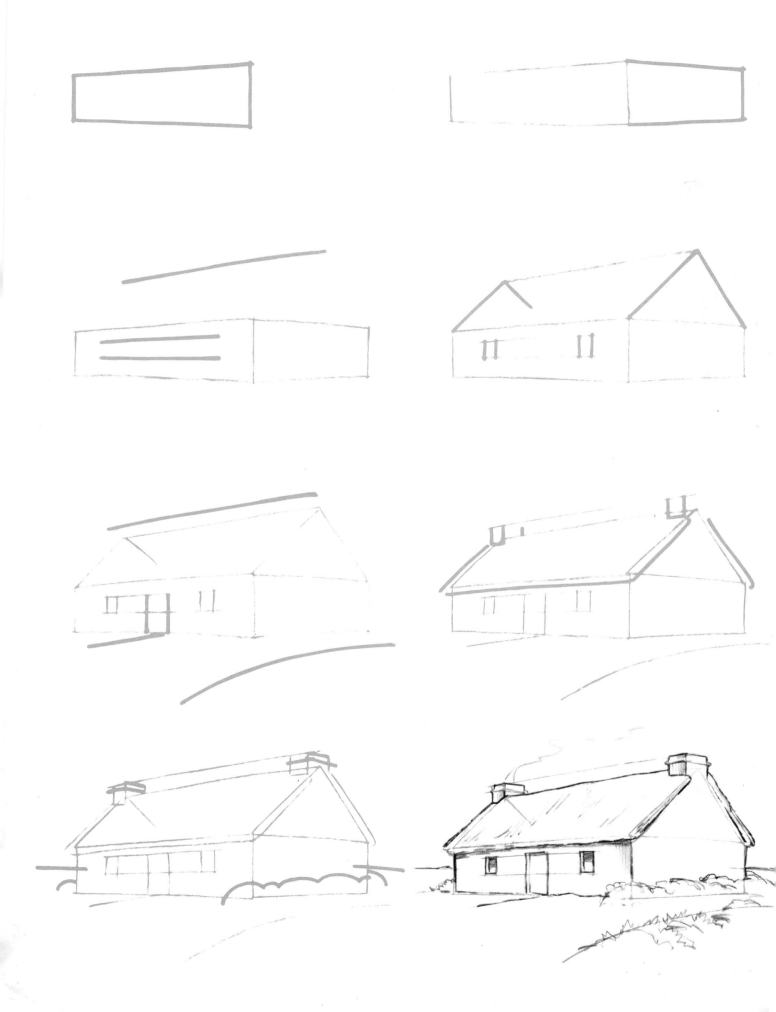

Southern Colonial House (U.S.A.)

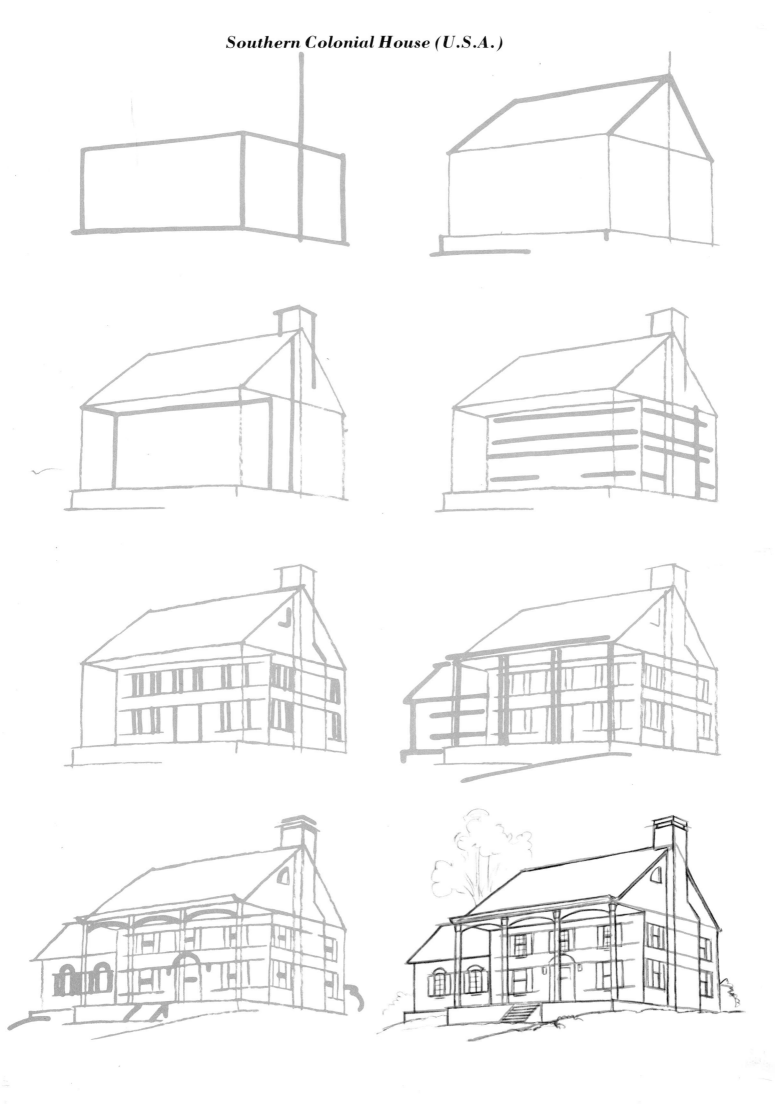

Sudanese Hut (Africa)

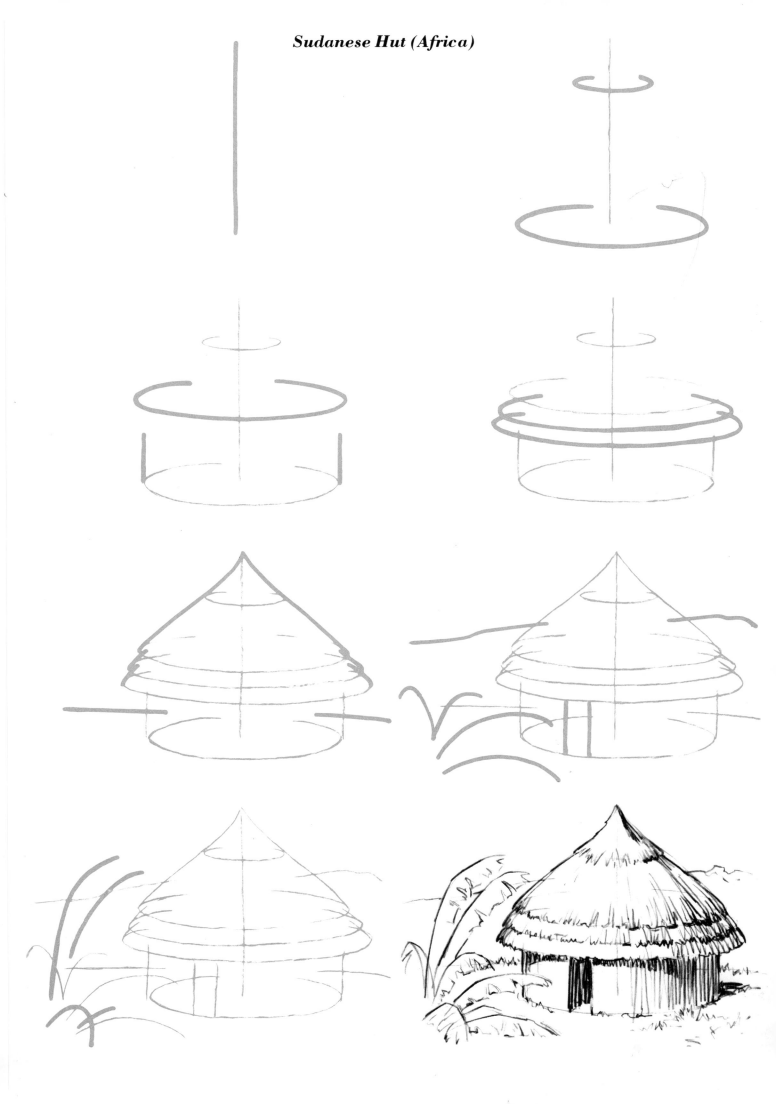

Log Cabin

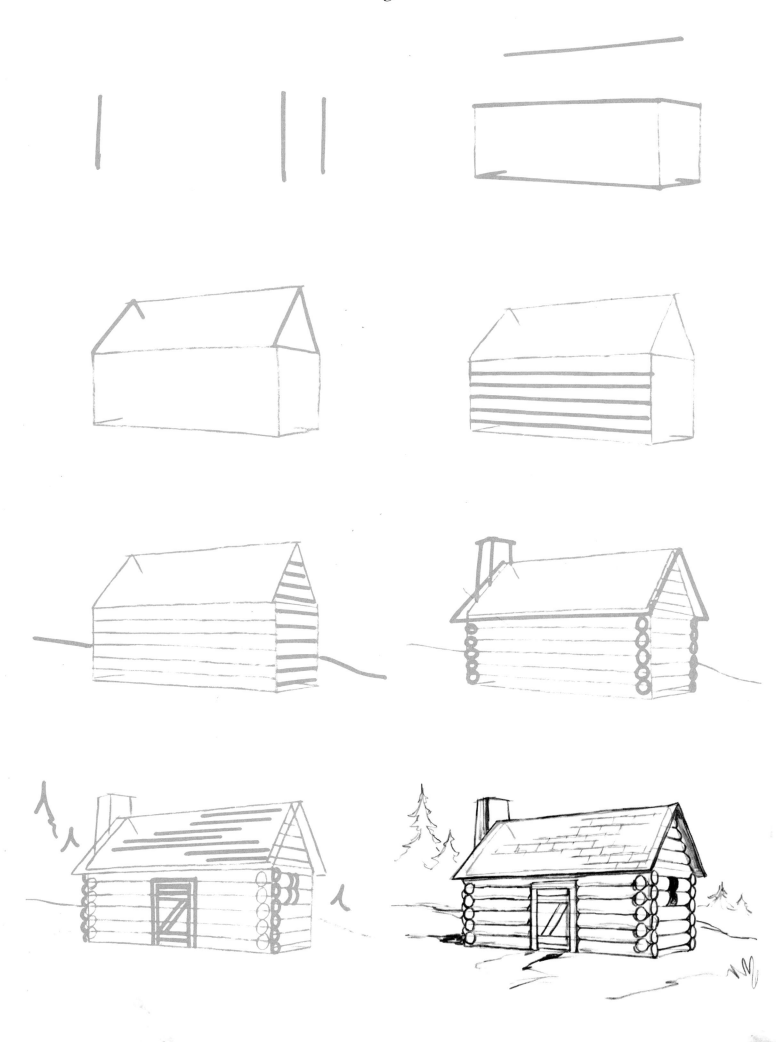

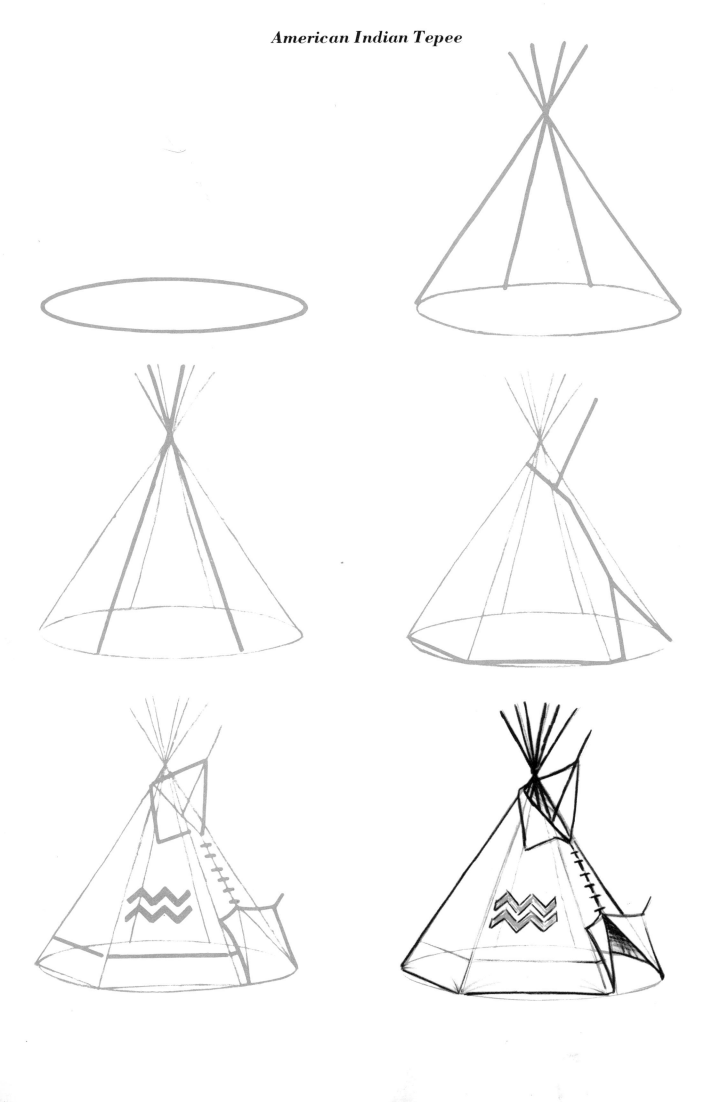

Eskimo Igloo

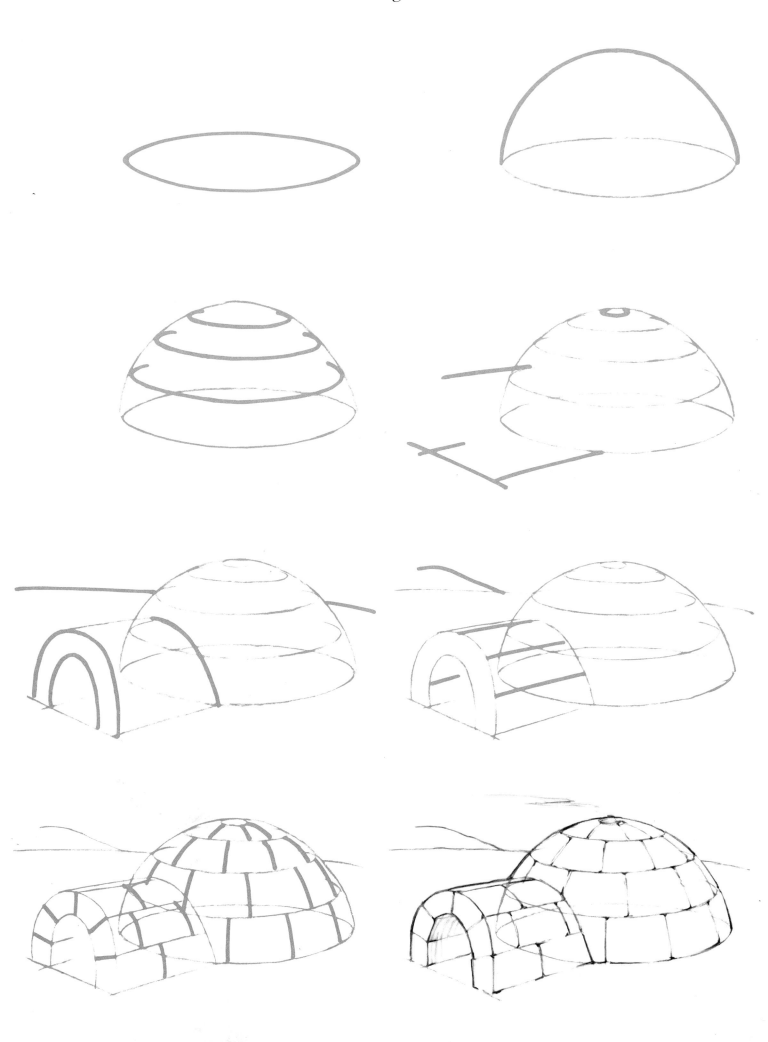

Shack

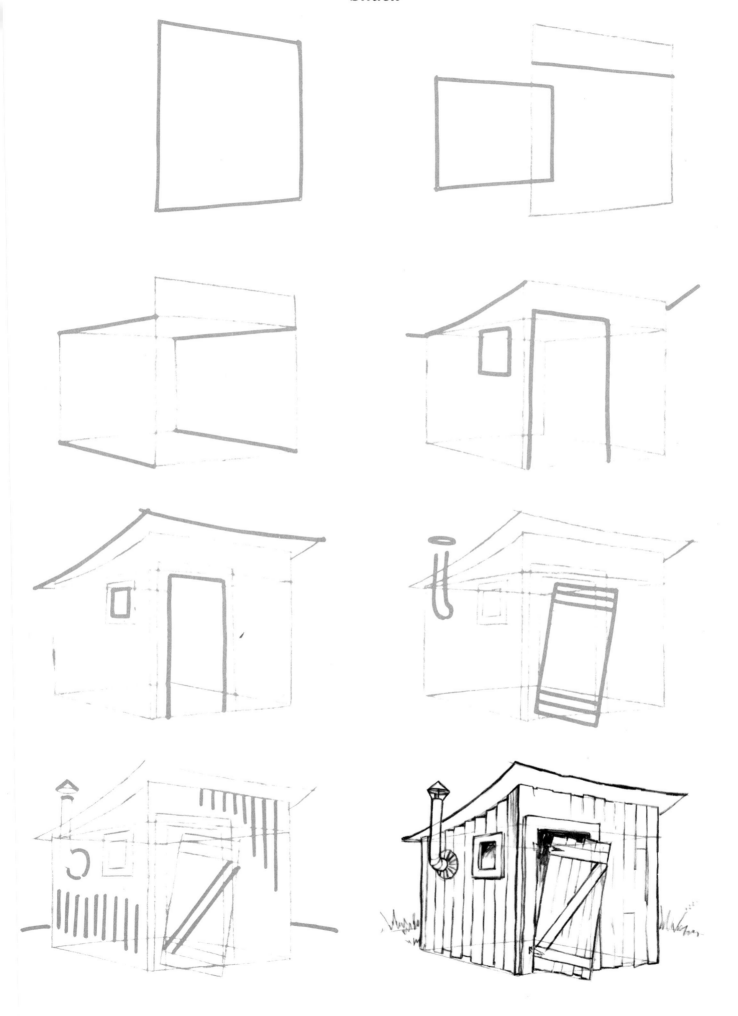

Circus Tent

Village Church (Vermont, U.S.A.)

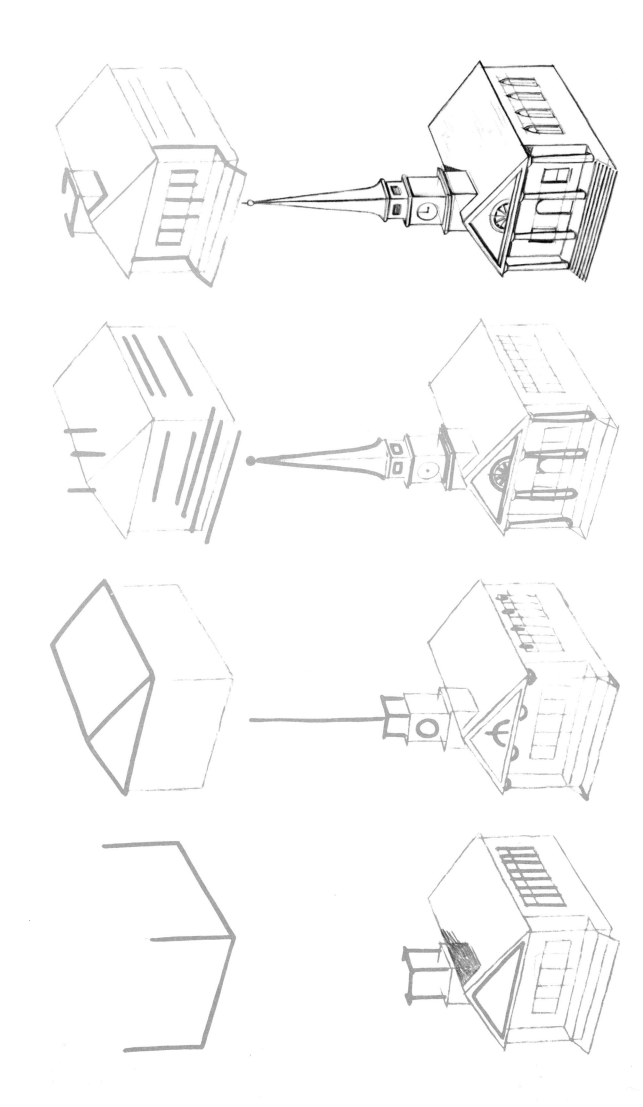

Block House in Stockade (U.S.A.)

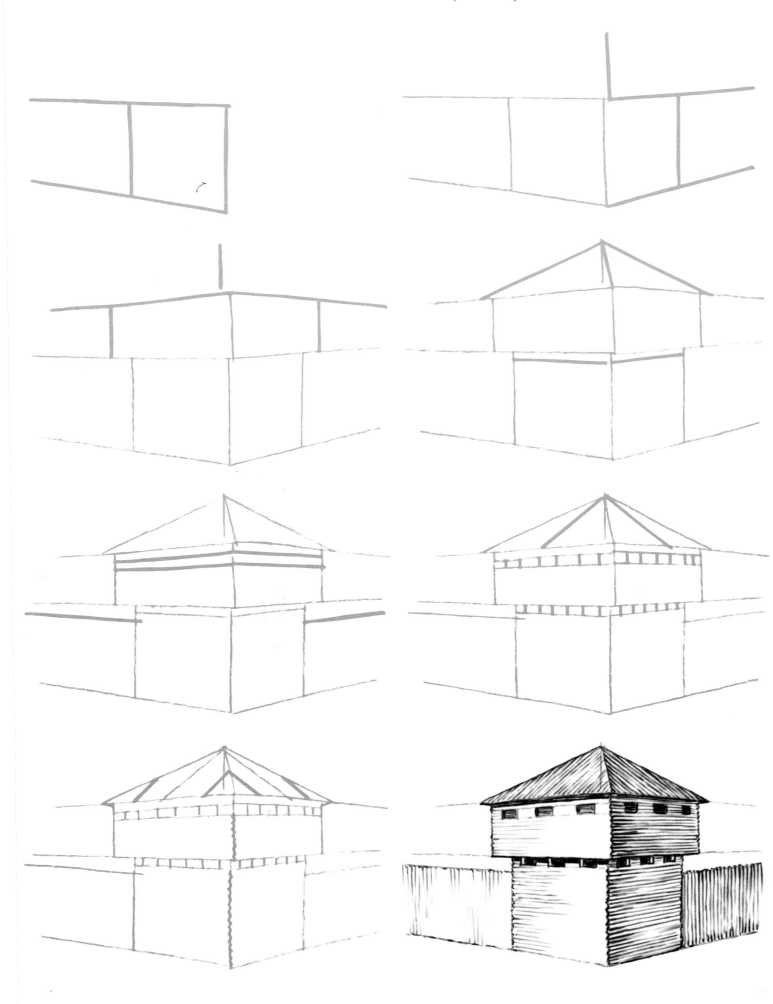

Barn and Silo

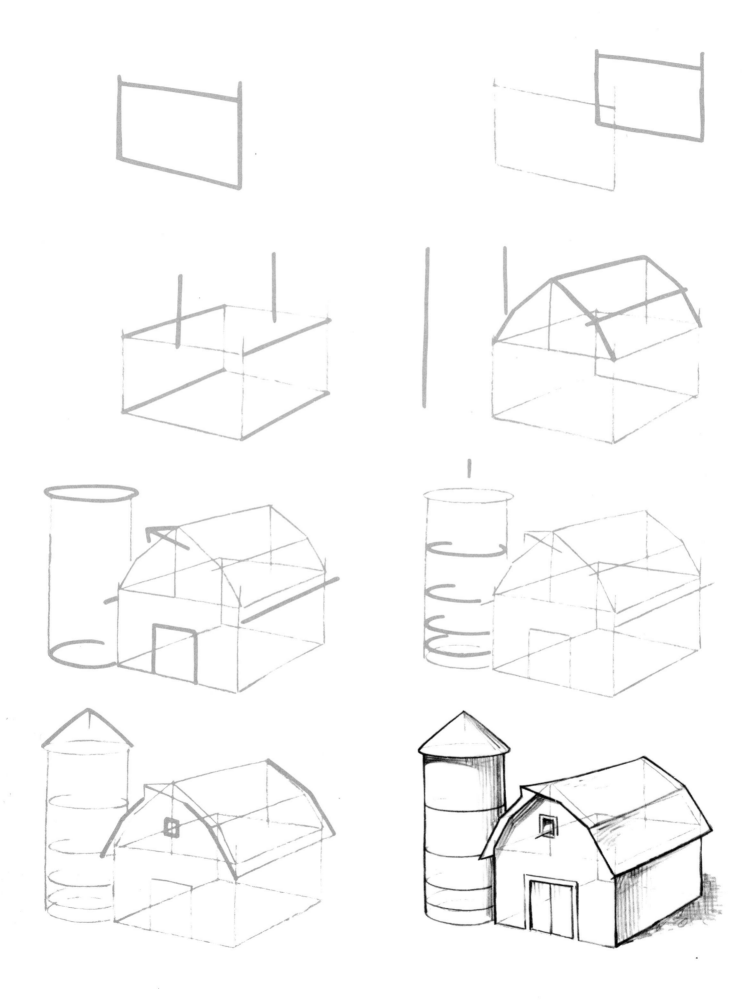

Lighthouse

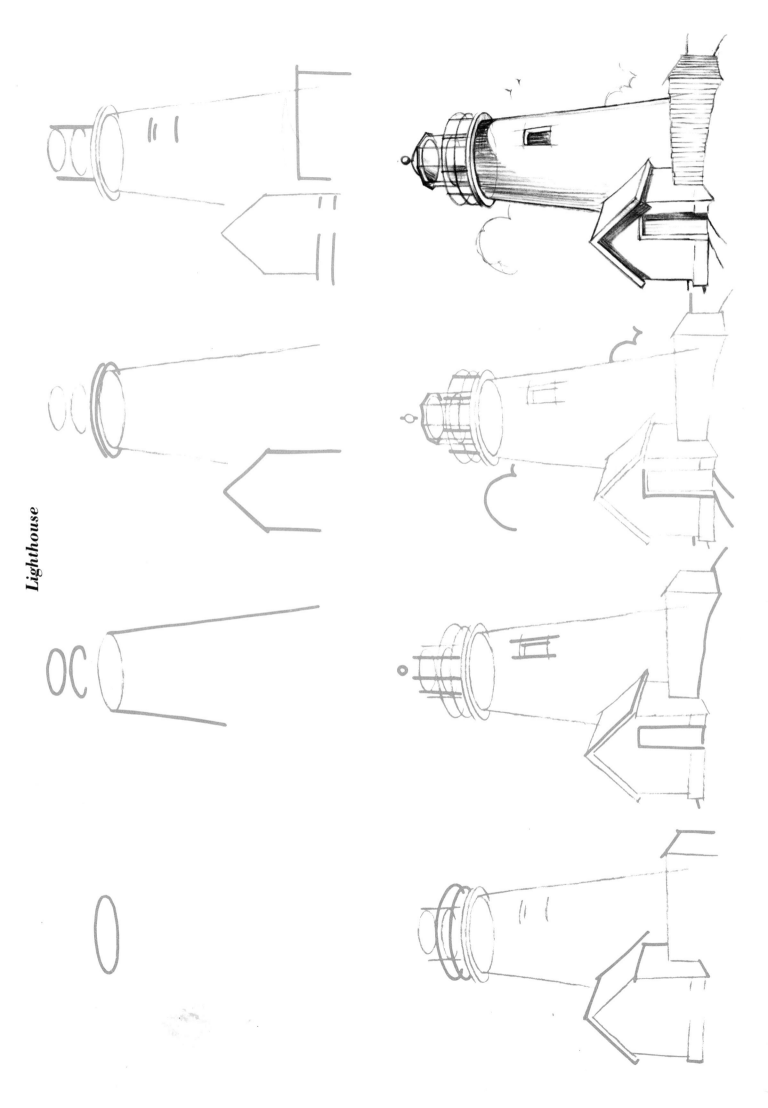

Overshot Watermill

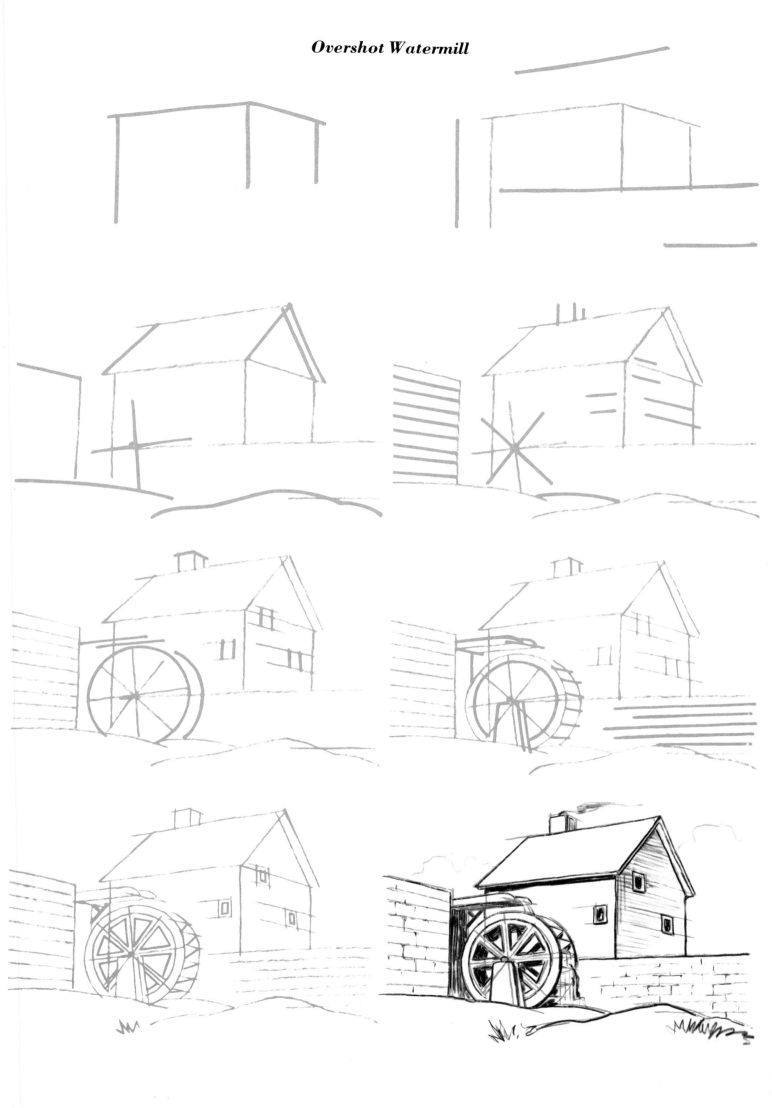

Eiffel Tower (Paris, France)

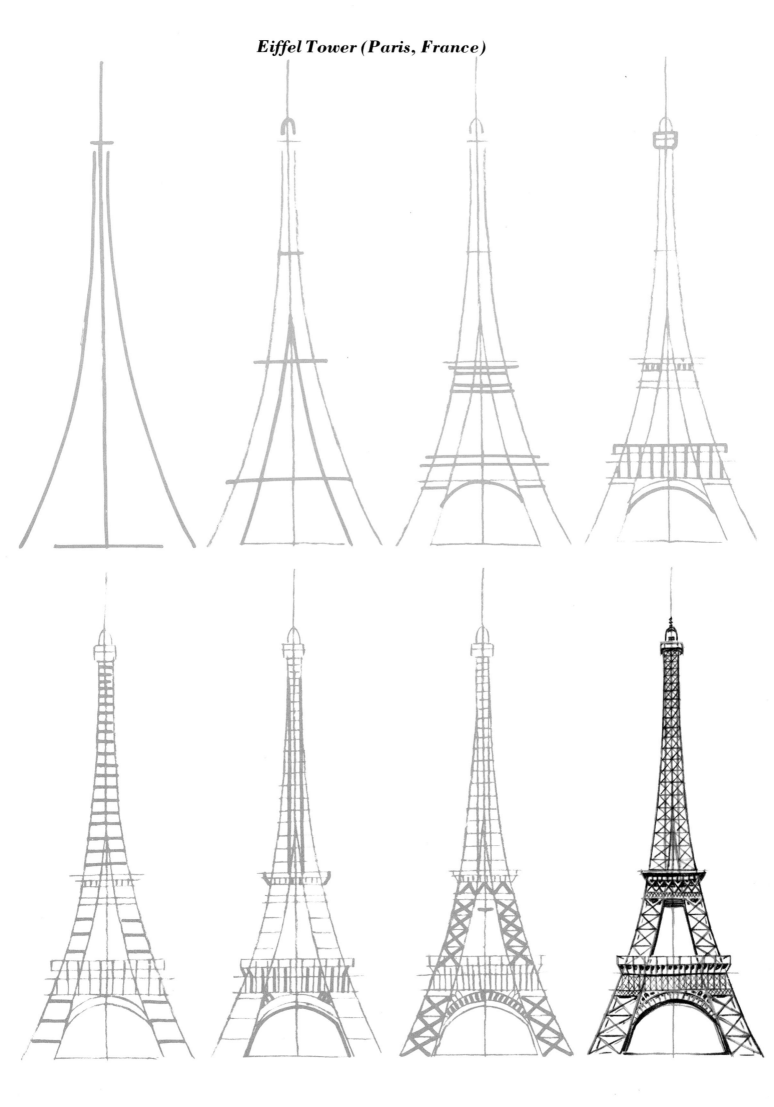

Pyramids (Gizeh, Egypt)

L'Arc de Triomphe (Paris, France)

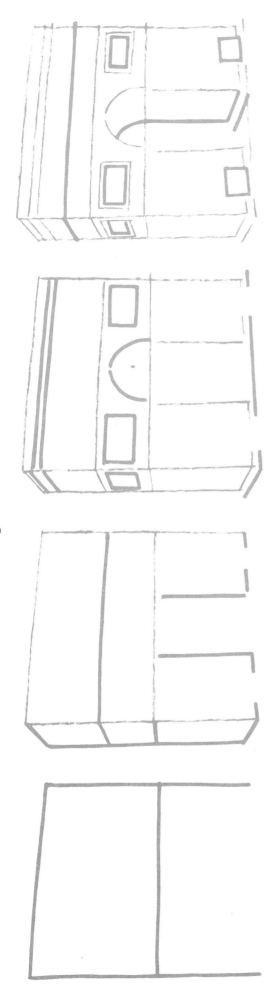
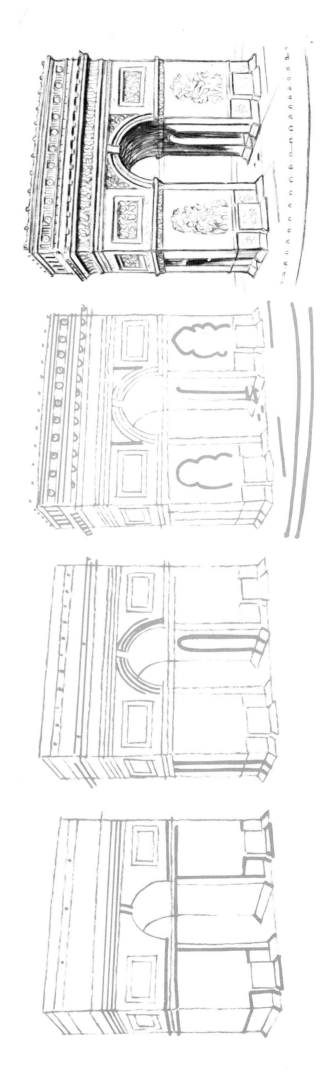

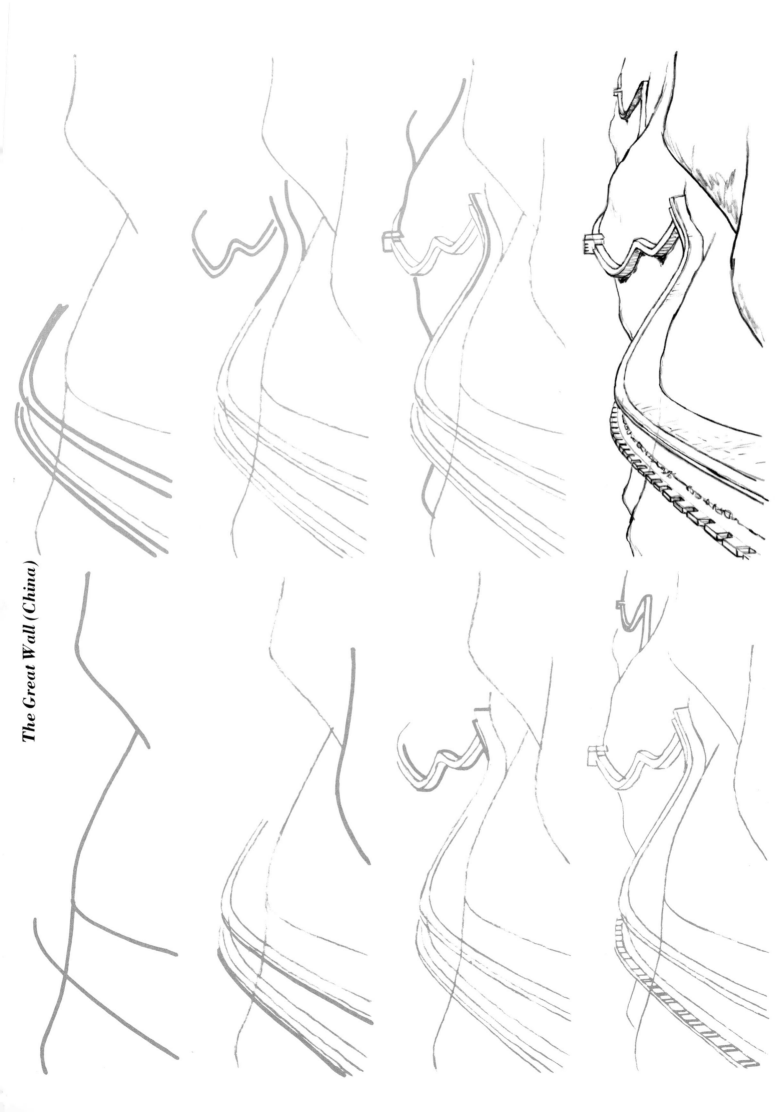

The Great Wall (China)

Mayan Pyramid (Mexico)

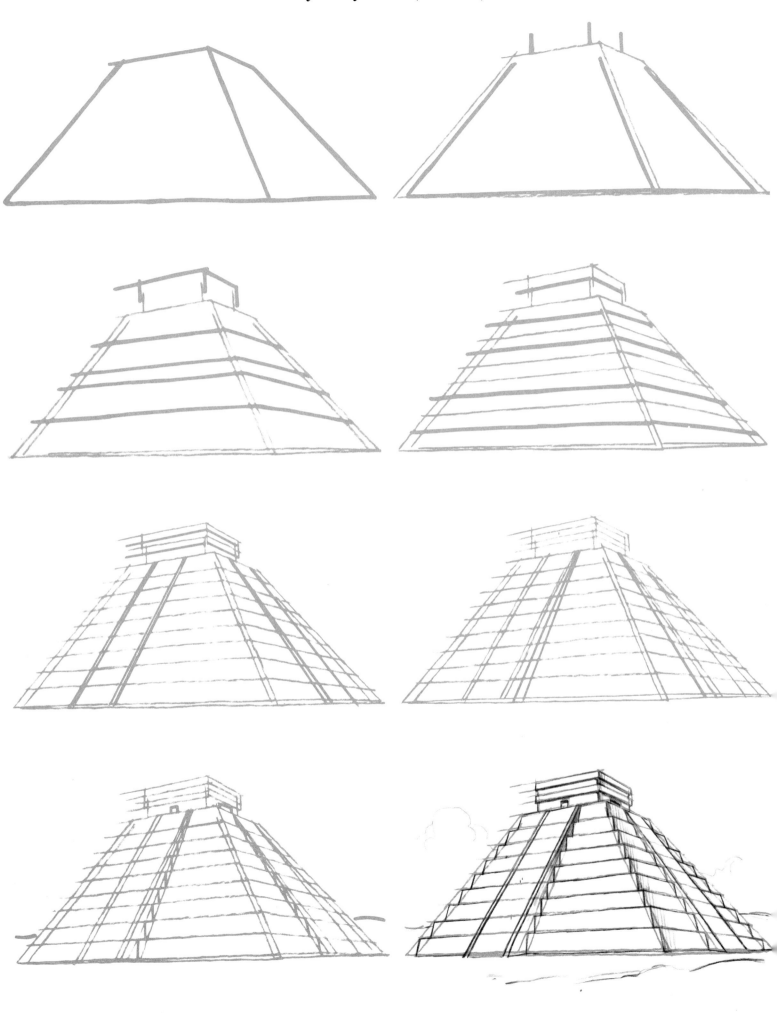

Torii (Japan)

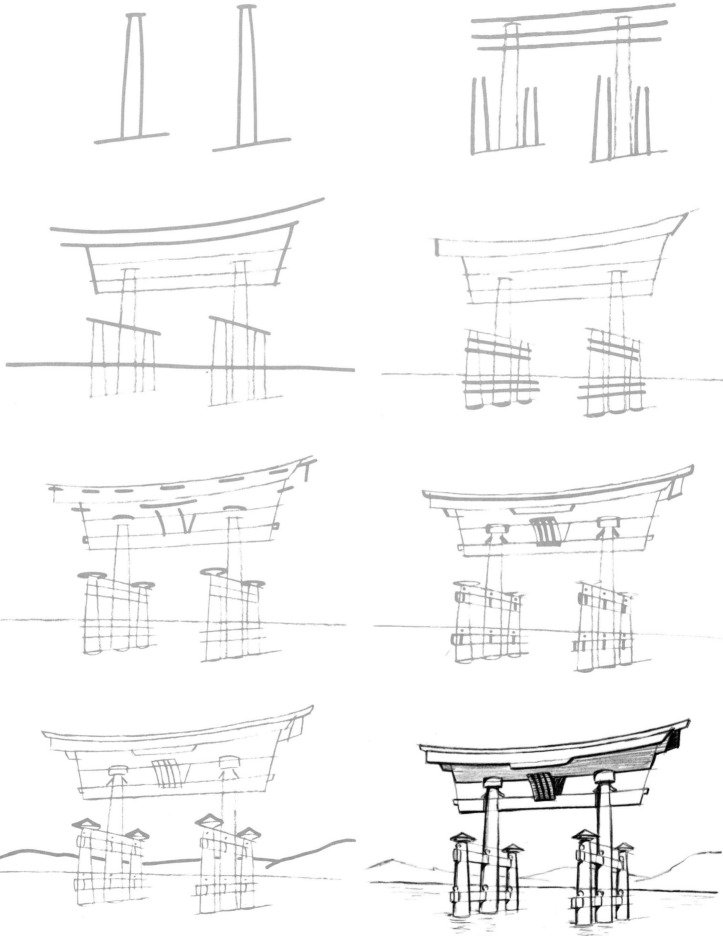

Golden Gate Bridge (California, U.S.A.)

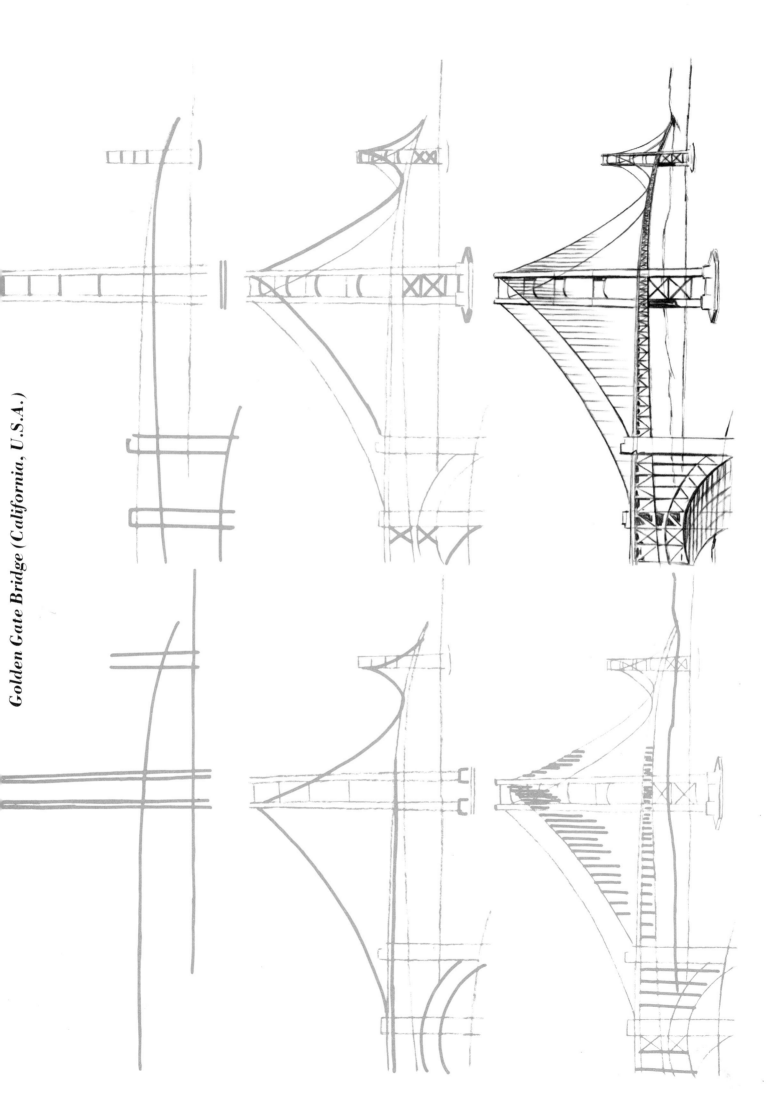

Brooklyn Bridge (New York, U.S.A.)

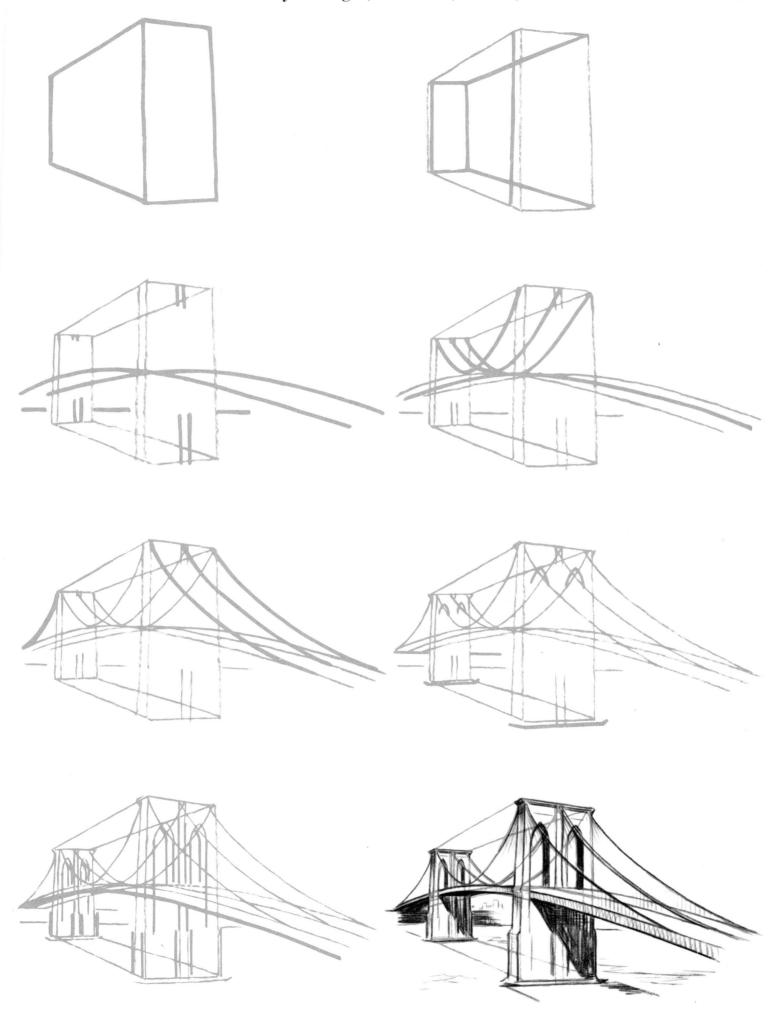

Sydney Harbor Bridge (Sydney, Australia)

Stone Bridge

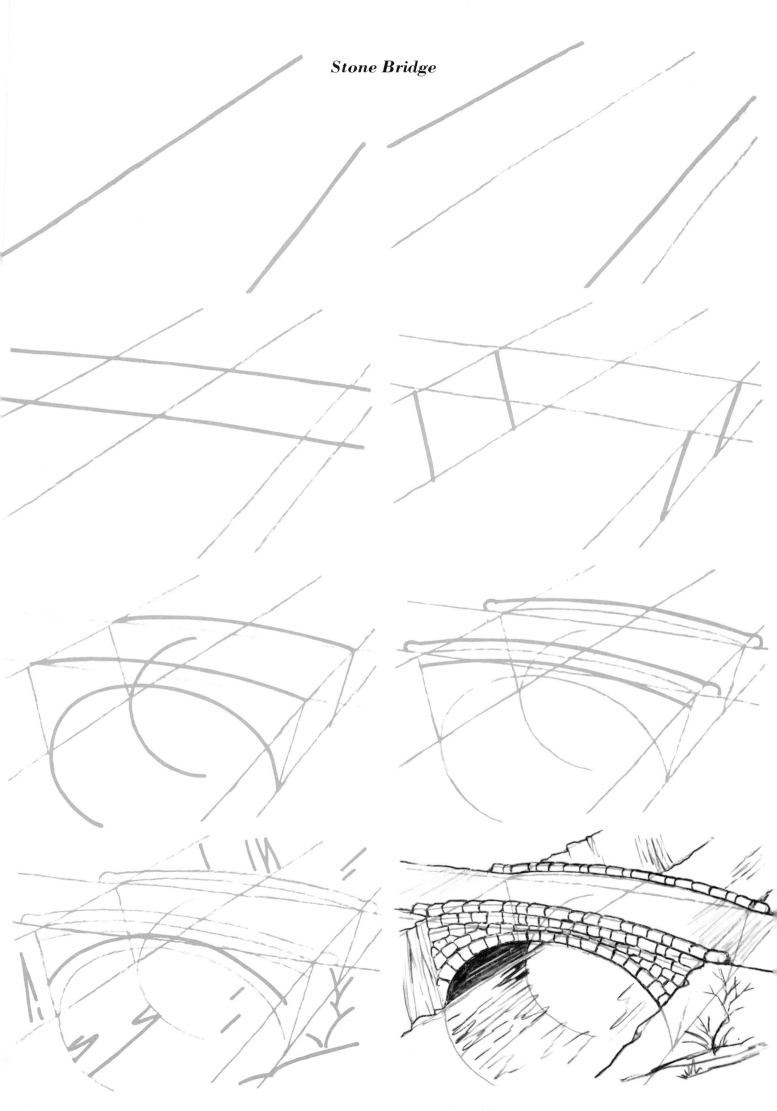

Covered Bridge

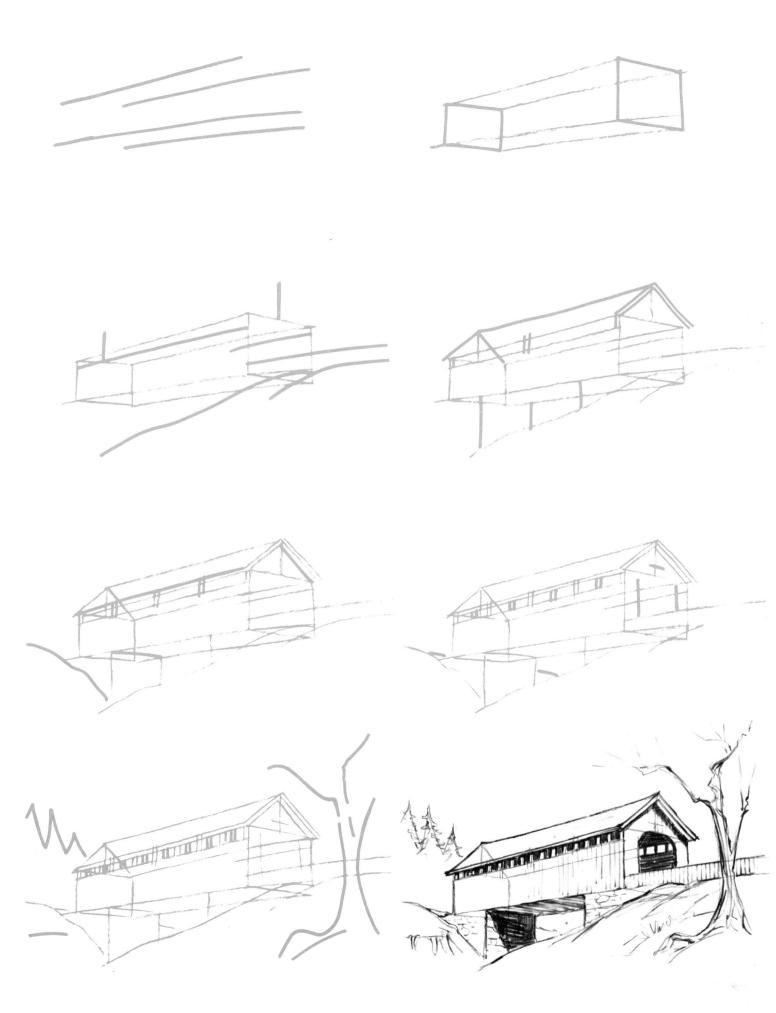

Ponte Vecchio (Florence, Italy)

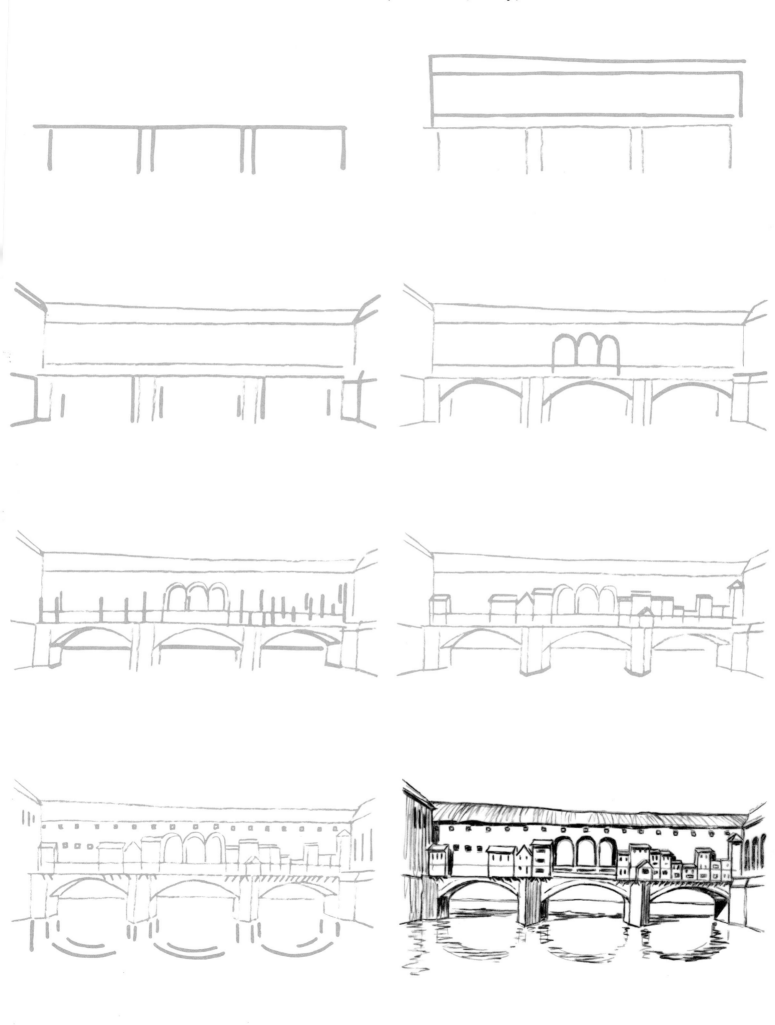

Author Biography

LEE J. AMES joined the Doubleday list in 1962, and since that time his popular drawing books have sold nearly two million copies. Utilizing a unique step-by-step method to guide the young artist's hand, Ames's "Draw 50" books have inspired the creativity of countless children (and adults).

His artistic experience runs the gamut from working at Walt Disney Studios in the days when *Fantasia* and *Pinocchio* were created to teaching at New York City's School of Visual Arts to running his own advertising agency. In addition, he has illustrated over 150 books, from preschool picture books to postgraduate texts.

When not working in his studio, Lee can be found on the tennis courts of Long Island, New York, where he currently lives with his wife, Jocelyn.

DRAW 50 FOR HOURS OF FUN!

Using Lee J. Ames's proven, step-by-step method of drawing instruction you can easily learn to draw animals, monsters, airplanes, cars, sharks, buildings, dinosaurs, famous cartoons, and so much more! Millions of people have learned to draw by using the award-winning "Draw 50" technique. Now you can too!

COLLECT THE ENTIRE DRAW 50 SERIES!

*The Draw 50 Series books are available from your local bookstore.
You may also order direct (make a copy of this form to order).*

Titles are paperback, unless otherwise indicated.

ISBN	TITLE	PRICE	QTY	TOTAL
23629-8	Airplanes, Aircraft, and Spacecraft	$8.95/$11.95 Can	X ___ =	_____
19519-2	Animals	$8.95/$11.95 Can	X ___ =	_____
24638-2	Athletes	$8.95/$11.95 Can	X ___ =	_____
26767-3	Beasties and Yugglies and Turnover Uglies and Things That Go Bump in the Night	$8.95/$11.95 Can	X ___ =	_____
23630-1	Boats, Ships, Trucks and Trains	$8.95/$11.95 Can	X ___ =	_____
41777-2	Buildings and Other Structures	$8.95/$11.95 Can	X ___ =	_____
24639-0	Cars, Trucks, and Motorcycles	$8.95/$11.95 Can	X ___ =	_____
24640-4	Cats	$8.95/$11.95 Can	X ___ =	_____
42449-3	Creepy Crawlies	$8.95/$11.95 Can	X ___ =	_____
19520-6	Dinosaurs and Other Prehistoric Animals	$8.95/$11.95 Can	X ___ =	_____
23431-7	Dogs	$8.95/$11.95 Can	X ___ =	_____
46985-3	Endangered Animals	$8.95/$11.95 Can	X ___ =	_____
19521-4	Famous Cartoons	$8.95/$11.95 Can	X ___ =	_____
23432-5	Famous Faces	$8.95/$11.95 Can	X ___ =	_____
47150-5	Flowers, Trees, and Other Plants	$8.95/$11.95 Can	X ___ =	_____
26770-3	Holiday Decorations	$8.95/$11.95 Can	X ___ =	_____
17642-2	Horses	$8.95/$11.95 Can	X ___ =	_____
17639-2	Monsters	$8.95/$11.95 Can	X ___ =	_____
41194-4	People	$8.95/$11.95 Can	X ___ =	_____
47162-9	People of the Bible	$8.95/$11.95 Can	X ___ =	_____
47005-3	People of the Bible (hardcover)	$13.95/$19.95 Can	X ___ =	_____
26768-1	Sharks, Whales, and Other Sea Creatures	$8.95/$11.95 Can	X ___ =	_____
14154-8	Vehicles	$8.95/$11.95 Can	X ___ =	_____
	Shipping and handling	**(add $2.50 per order)**	X ___ =	_____
		TOTAL		_____

Please send me the title(s) I have indicated above. I am enclosing $_____.
Send check or money order in U.S. funds only (no C.O.D.s or cash, please). Make check payable to Doubleday Consumer Services. Allow 4 - 6 weeks for delivery.
Prices and availability are subject to change without notice.

Name:_____

Address:_____ Apt. # _____

City:_____ State:_____ ZIP Code: _____

Send completed coupon and payment to:
Doubleday Consumer Services
Dept. LA 26
2451 South Wolf Road
Des Plaines, IL 60018

MAIN STREET BOOKS